LEARN FROM THE MASTERS
Create your own watercolours
in the style of

J. M. W. TURNER

DATE DUE

founded her own art school in Hinterzarten, Germany, and from 1985 she was the director of an art school which she established at Schluchsee in the Black Forest. In 1988 she was appointed to teach oil painting at the Art College, Kashmir.

Angelika has also been acclaimed for her solo exhibitions, which have been held in various countries around the world.

LEARN FROM THE MASTERS

*Create your own watercolours
in the style of*

J. M. W. TURNER

Angelika Khan-Leonhard

SEARCH PRESS

Contents

Learn from the Masters

For centuries painters have imitated masterpieces, both to improve their techniques and to develop an individual style, and copying the masters is often an essential part of an artist's training. Of course, it calls for considerable knowledge and skill, and any painter wishing to follow in the steps of the masters must first analyse original works in detail. *Learn from the Masters* has been specially designed to enable you to do just this.

Each book in this series shows how a leading watercolourist actually worked. Learn something about the master's life, how he saw things, and how he used certain techniques of form and colour in watercolour painting. Discover through step-by-step demonstrations how to reconstruct the original picture and how to recreate details of the work in the same way. Find out also how to translate modern views into the same style as the original painting.

As you discover more about the artist and his work, it is likely that you will become more aware of the distance in time that separates you. This will encourage you to develop your own creative style, using the skills and techniques that you have learnt from the past.

Other books in the series feature artists such as Cézanne, Van Gogh, and Gauguin.

J.M.W. Turner

Life and work

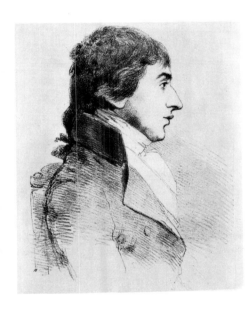

Joseph Mallord William Turner is acknowledged by many to be the greatest of English painters in watercolour, and his paintings bear impressive witness to his genius. Amongst his contemporaries he was unique, both in freeing himself from all past traditions and movements and in his visionary anticipation of modern painting.

Turner was born in London on 23 April 1775. His father, a Covent Garden barber and wig-maker, soon recognized and began to promote his son's talent, enrolling him at the Royal Academy Schools in 1789. Only one year later, Turner exhibited a watercolour in the Academy's annual exhibition.

Turner was taught perspective by a topographer, who also showed him how to colour drawings and engravings. He studied and copied the landscape sketches of John Robert Cozens, being strongly affected by their dramatic subject-matter and lively colours. His passion for landscape painting was awakened, and his topographical watercolours were publicly admired as early as 1794.

In 1802, Turner was elected a full Royal Academician. In the same year, he visited Paris and studied the pictures in the Louvre, finding Titian and Poussin especially beguiling. He produced many watercolours and drawings at this time.

In later years, Turner's work was increasingly determined by the transparency of colour and light. Initially, however, he remained faithful to classical tradition. Dutch painting and the French painter Claude Lorrain, his great model, were major influences on him. In 1807, the first volume of his *Liber Studiorum*, an ambitious work on the art of landscape painting, appeared, and later that year he was appointed Professor of Perspective at the Royal Academy.

Turner lived with a musician's widow and had two children. He travelled a great deal, visiting the Netherlands, Belgium and the Rhine. It was his trips to Italy, though, which most influenced his style, and he recorded his impressions of this country in numerous sketches, watercolours and oils.

Turner's father, who had always accompanied his son and looked after his business affairs, died in 1829. Four years later, Turner met Mrs Booth, a widow with whom he

lodged and who was to become his lifelong companion.

In the years after his father's death, Turner often stayed at Petworth, Sussex, the home of his friend and patron the Earl of Egremont. Like his Italian visits, this period had a profound influence on Turner's work. Increasingly, he began to focus his painting on the forces of nature and found the battle of the elements so fascinating that he even had himself lashed to a ship's mast for direct experience of storms at sea. When fire consumed the Houses of Parliament he was deeply affected by the dramatic power of the event and recorded it in a dynamic composition.

In 1840, Turner and John Ruskin, who was later to become his friend and biographer, met for the first time. Three years later, Ruskin published volume one of *Modern Painters* in which he gave a detailed account of Turner's work and his leading position amongst English artists.

Towards the end of his life, Turner was so deeply involved with nature that he could identify with the elementary forces of wind, fire and water. This enabled him to reproduce nature's primal power in his paintings. He painted ecstatic visions of the drama of nature in all its grandeur, perceiving and presenting his subject-matter in a revolutionary way. An artist was now at work who understood his motifs from within and was able to express their very soul in his pictures.

Turner died on 19 December 1851 and was buried in St Paul's Cathedral, London. He left nearly 20,000 watercolours and drawings, which he bequeathed to the nation.

Watercolour techniques

What seems at first a rather 'sketchy' effect in Turner's watercolours is, in fact, the result of his unrelenting observation and his fluid and accomplished style.

Turner made a thorough study of traditional techniques, which he held at his fingertips. At the same time, his creative urge caused him to experiment, which he did until the end of his life. After his study of Cozens's work, Turner's hitherto conventional way of seeing things changed, and he developed a new visual approach dominated by light and colour, which he expressed regardless of public opinion. This approach has retained its overwhelming power right up to the present day.

For watercolour painting, Turner often used paper which was already toned or which he toned in advance. The first thing he did was to lay down colour washes, using a lot of water. Then, he integrated these washes into the background to produce an illusion of depth, using a drier brush for structures. Only towards the end of the painting did he use a fine brush or pen for details. To obtain hazy effects, he dipped the sheet of paper in water and scratched out certain areas with a knife or his fingernail. By these means he achieved colour harmonies of the greatest beauty.

Turner was distinguished for his supremely accomplished handling of the watercolour medium. In spite of his free and relaxed treatment of surface and colour, his interpretation of his subject-matter was highly expressive and realistic.

On the following pages you can discover Turner's style and working methods, using as your example his watercolour *Venice: the Grand Canal, looking towards the Dogana* which was painted in Venice itself.

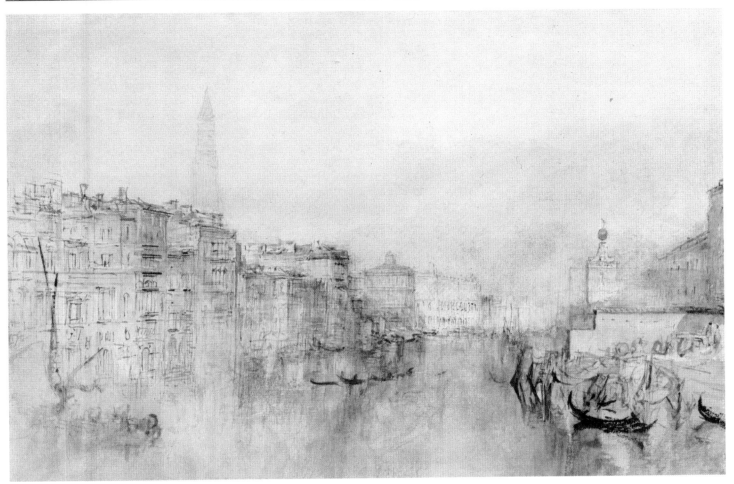

Venice: the Grand Canal, looking towards the Dogana

Original watercolour by Turner

Size: 320 × 221mm (12¾ × 8¾ in)

In this watercolour, painted in 1840, Turner presented a topographically accurate view of Venice.

It would be difficult to find an atmosphere more typical of his work than in this painting. The original fleeting impression is reproduced by effects of light and colour, and the facades of the houses, the water, and the boats are covered in a fine haze.

Materials and equipment

The materials and equipment that you will need to produce your own watercolours in the style of Turner are relatively few and inexpensive.

Paper: smooth watercolour or hand-made paper, Ingres paper.

Artist's watercolours: lemon yellow, cobalt blue, yellow ochre, rose madder (genuine rose madder is expensive, but there are many suitable synthetic substitutes which can be obtained easily), burnt umber, Chinese white.

Brushes: pointed hair brushes nos. 3 and 6, flat-ended hair brushes nos. 8 and 10 (used also for oils).

Other equipment: medium-sized nib and penholder, 3B pencil, soft artist's eraser, water trays, artist's palette, drawing board, roll of gummed paper tape, natural sponge.

Drawing techniques

Usually, Turner drew his subject-matter with generous, spirited lines. However, he often sketched his Venetian views using more precise, representational pencil strokes, which, for the most part, he then retained as elements of the final picture. In colour studies, he stressed the graphic elements individually with fine brush or pen strokes.

Paper stretching

Any cockles or wrinkles in the surface of your paper will affect the application of your paint. Therefore, it is a good idea to stretch the paper before using it, particularly when it is over 180 × 240mm (7¼ × 9½ in) in size.

Cut four strips of gummed paper tape, each a little longer than the edges of the sheet of paper. Moisten the paper thoroughly, either by dipping it in a tray of water or by holding it under a running tap. Allow the surplus water to drain off, then lay the paper flat on a smooth drawing board. Use a sponge to smooth away any bubbles, working from the middle outwards. Leave the paper to expand for approximately five minutes, then fix it to the board by sticking the gummed paper tape along its edges. It will take approximately six hours to dry.

Painting techniques

In order to create the atmosphere demanded by the scene, Turner often toned white paper with a faint, preliminary colour wash.

After applying this preliminary wash and allowing it to dry, you should draw in your motif with a soft pencil before applying any further washes. Alternatively, you can carry out your pencil work before applying even the first wash.

Colour

Turner laid his colour washes boldly on the surface. He often moistened the paper in advance and then laid wash over wash. When putting in the detail, he usually painted the colour onto a dry surface. He achieved his typically effortless colour transitions with paints heavily thinned with water.

Turner often used sepia ink, either pure sepia for painting details, or sepia mixed with watercolour.

However, sepia ink requires a very steady hand, as it is impossible to make corrections with water.

With darker papers Turner used an opaque white for heightening, that is, introducing points of light or illuminating colours.

Since colours from various manufacturers usually differ slightly in tonal value, it is worth testing your colours on a sheet of white paper before using them on the work itself.

Reconstruction after the original

Size: approximately 320 × 220mm
(12¾ × 8¾ in)
Colours: yellow ochre, lemon yellow, cobalt blue, rose madder

The composition of this watercolour can be divided into large drawn elements, the main ones being the groups of houses to the left and to the right.

Only begin to fill in the details once you have drawn the basic structure. This will help you to avoid errors of perspective.

For reasons of space, the demonstration pictures on the following right-hand pages have been slightly reduced in size.

Stage 1

After completing the basic pencil work, moisten the paper with water. Apply your colour heavily at first, and then more weakly, using a thinned warm tone of yellow ochre with just a trace of rose madder.

Before the ground is dry, lightly dab cobalt blue onto the sky and onto the water in the canal, thus creating a colour demarcation between these areas and the house facades.

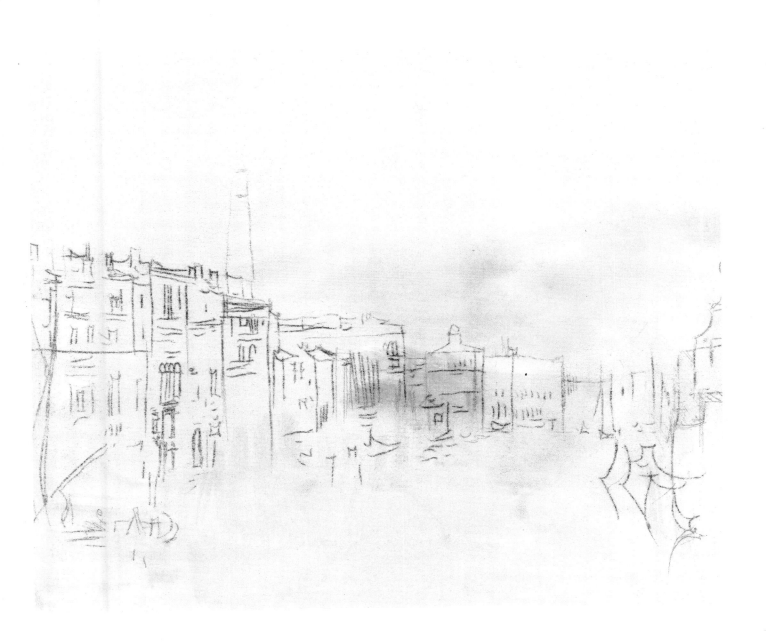

11

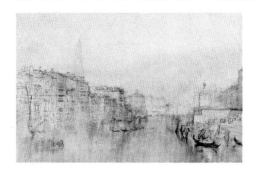

Stage 2

After softening some of the pencil lines with an eraser, touch the canal water with a mixture of rose madder and cobalt blue. If you keep the adjacent areas moistened with a brush, then you will obtain a smooth colour transition.

Use the same mixture, but with somewhat more blue, for the surface of the water in the background and for the shadows on the facades. Extend the shadows and reflections until they are fine stripes on the moistened ground.

Use a fine brush for the lines on the buildings, and then apply the colour to the surface areas with a larger brush.

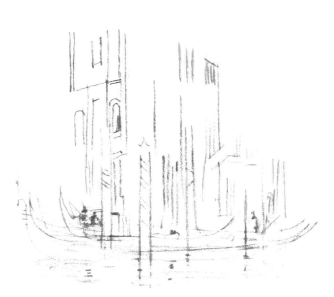

In order to gain a precise grasp of how the original picture was constructed, it is worth making some separate pencil sketches, e.g. of the architectural details, before continuing with your brushwork.

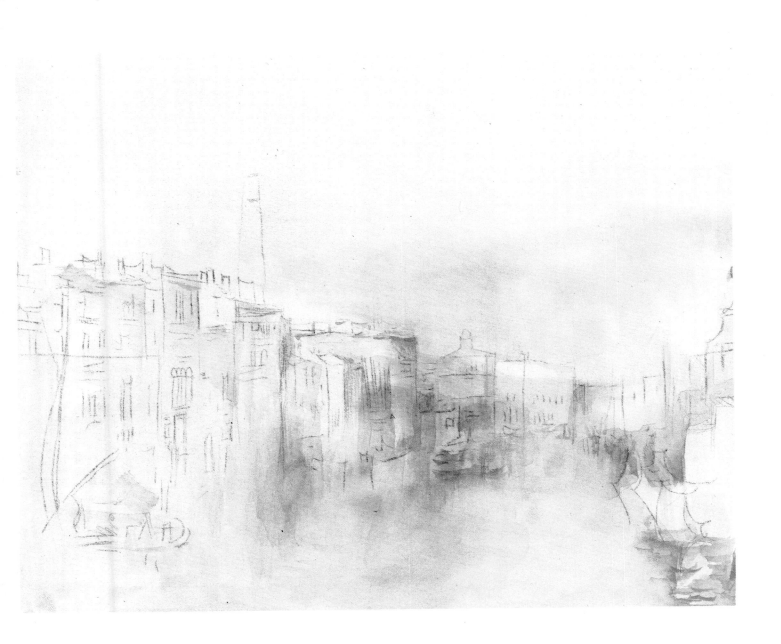

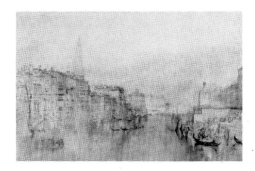

Stage 3

Pencil in the missing subsidiary lines and details such as boats. Next, lay a wash of lemon yellow and rose madder, starting with the roofs at the top left of the picture and working downwards and to the right. To ensure that the resulting tones are varied, work simultaneously with water and a colour brush. Extend the colour onto the surface of the water to create a reflection of the buildings. If you go over it again with a broad, damp brush, then you will achieve Turner's famous 'blurred' effect.

Using the same tone, lay the next wash on the still damp washes of the house facades, working from top to bottom in accordance with the structural lines of the buildings.

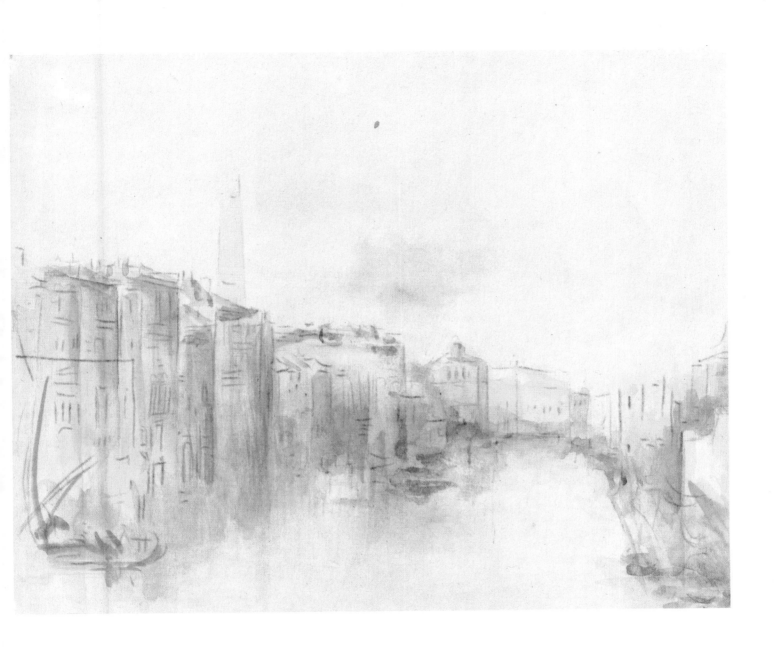

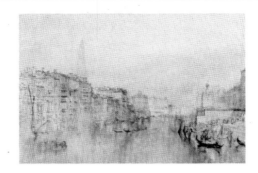

Stage 4

Erase more of the preliminary pencil drawing. Then, add the outlines of the buildings, and their windows and doors, using a mixture of lemon yellow, rose madder and a trace of cobalt blue. Use a fine brush and vary the weight of your brush strokes. With a very dry brush, apply the same tone to parts of the surface of the buildings.

Increase the amount of rose madder and emphasize the lines here and there. This is a slow process which requires care, but it is only by this method that you will be able to reproduce the architecture in Turner's style.

Instead of using a fine brush, you may prefer to draw in the fine outlines with a pen.

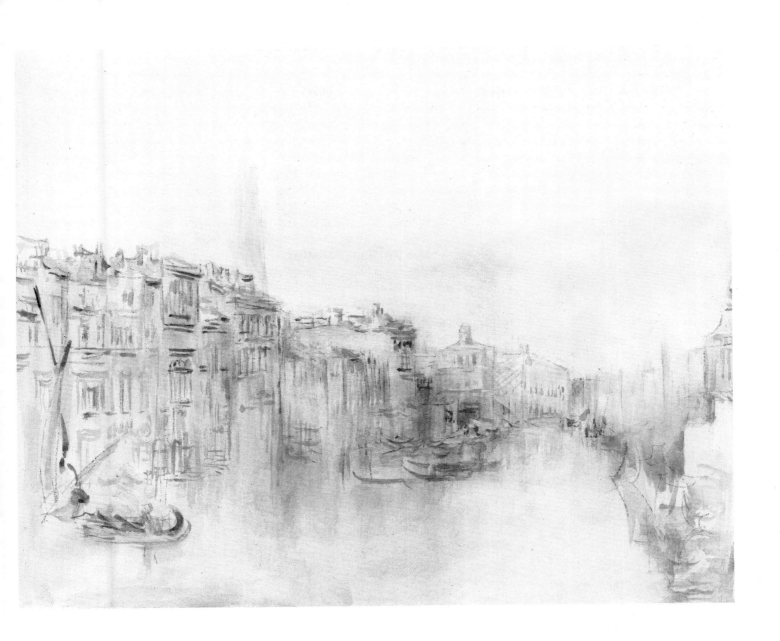

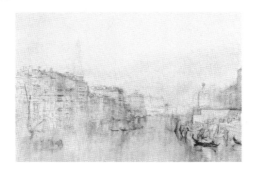

Stage 5 – the finished painting

Bring out further details with the same mixture of rose madder, a little cobalt blue and lemon yellow. Next, moisten the surface of the water and allow a new soft tone of cobalt blue and yellow ochre to flow into the background.

Finally, introduce light into the foreground of the picture, using a bright yellow mixed from yellow ochre and lemon yellow.

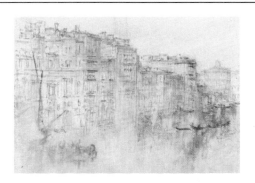

Detail from the original: Venetian houses

Size: 320 × 260mm (12¾ × 10½ in)
Colours: yellow ochre, lemon yellow, cobalt blue, rose madder

The detail chosen here to be developed into a composition in its own right is only one of several possibilities. Other attractive alternatives for enlargement include the boats in the central section together with the houses behind them, and the left foreground with the moving boat and the sails.

Use a small rectangular window cut from paper to isolate various parts of the picture and to test their suitability to stand alone.

Use the same method to look for subjects in nature. Cut a small paper window, approximately 2.5 × 2cm (1 × ¾ in), and hold it a little way from your eye. This will enable you to view the landscape as though you were looking through a camera lens.

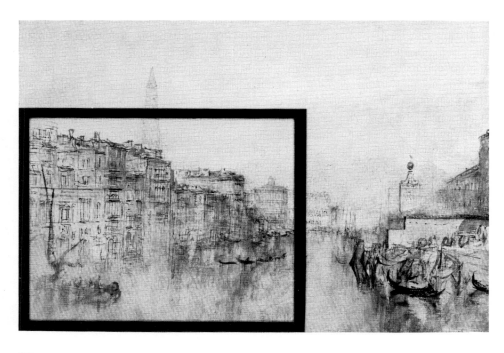

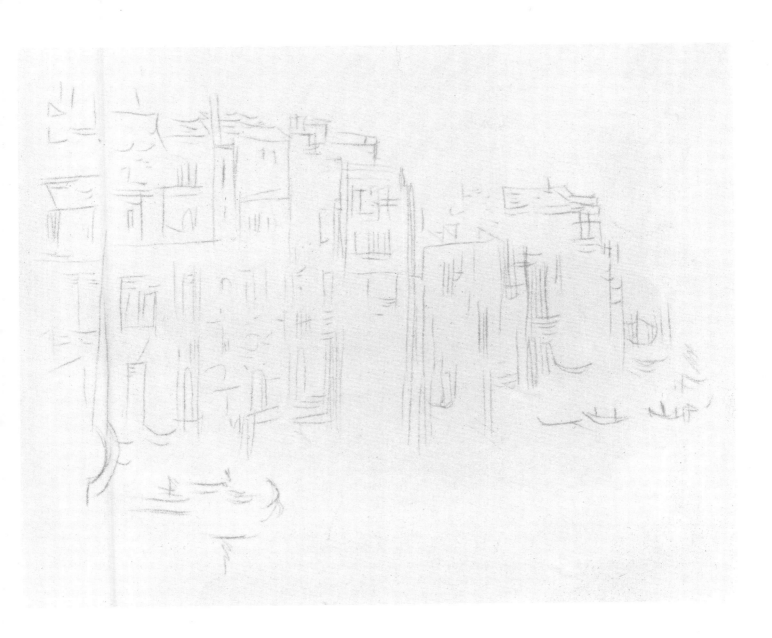

Stage 1

As with the reconstruction of the whole painting (see page 10), begin this watercolour with a pencil sketch. This will allow you to change the composition as you wish.

Moisten the paper and lay a warm yellow ground. Mix it from yellow ochre and lemon yellow, and apply it heavily in some areas and weakly in others.

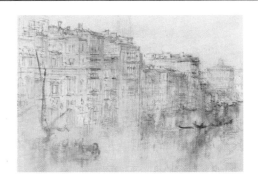

Stage 2

Use water to moisten parts of the sky and then allow a very thinned tone of cobalt blue to flow into it. Also, moisten parts of the water area before adding the colour, to ensure smoothly flowing blue surfaces. Heighten the house facades with the same tone, so that the colour connects the foreground and the background.

Next, add a mixture of lemon yellow and rose madder to the damp blue washes, extending it over the buildings, water, and sky.

With a light touch, add some clouds to the sky (once again moistened in advance) using a reddish tone mixed from rose madder and lemon yellow. Alternatively, a thin wash of sepia can be used instead of this mixture.

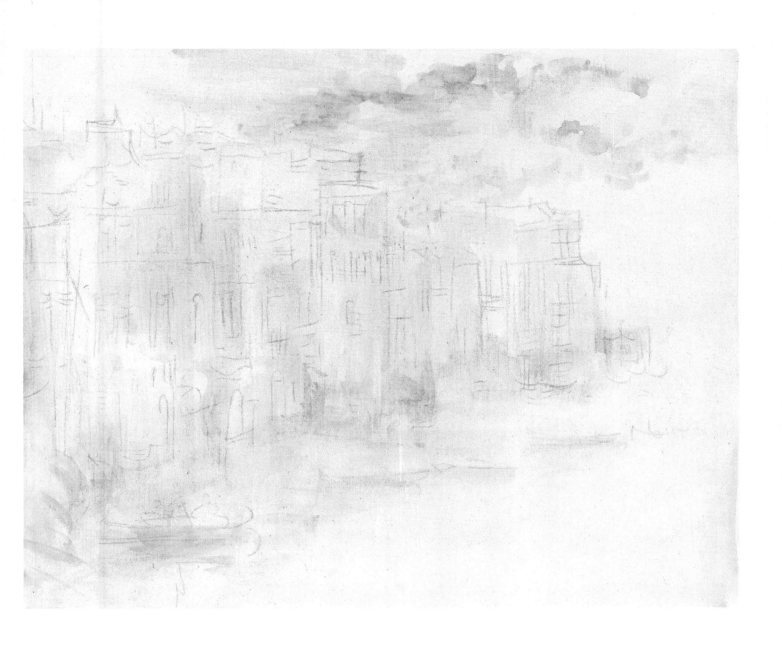

23

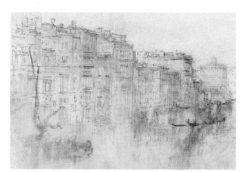

Stage 3

Emphasize the boats with fine pencil lines. Then, moisten the left edge of the picture and lay a wash from above to below, using a mixture of rose madder, yellow ochre and cobalt blue. Follow the structure of the buildings and include the boats and the reflections in the water.

Next, apply delicate green strokes, mixed from cobalt blue and lemon yellow, to the surface of the water. Use thinned rose madder and lemon yellow to emphasize details, such as the outlines of the houses and their windows and doors. Make another mixture of rose madder, yellow ochre and cobalt blue for the boats.

Detailed pencil sketches will help you to establish the structure of the boats. These drawings can also be used as the bases of separate compositions.

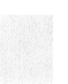

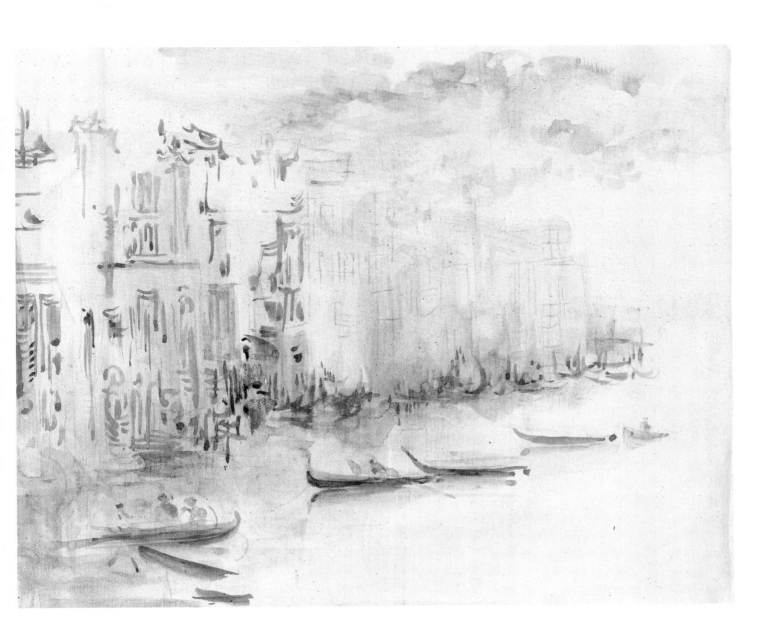

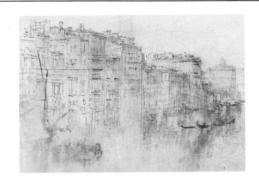

Stage 4 – the finished painting

Use a very strong mixture of rose madder, some cobalt blue and lemon yellow to develop the fine details. To brighten the tone a little, you can thin the colour with water. A fine brush or a pen should be used to bring out the contours, whilst any outlines that are too sharp can be softened with a damp brush. The reddish tones are points of emphasis, which enliven and provide a structure for the picture.

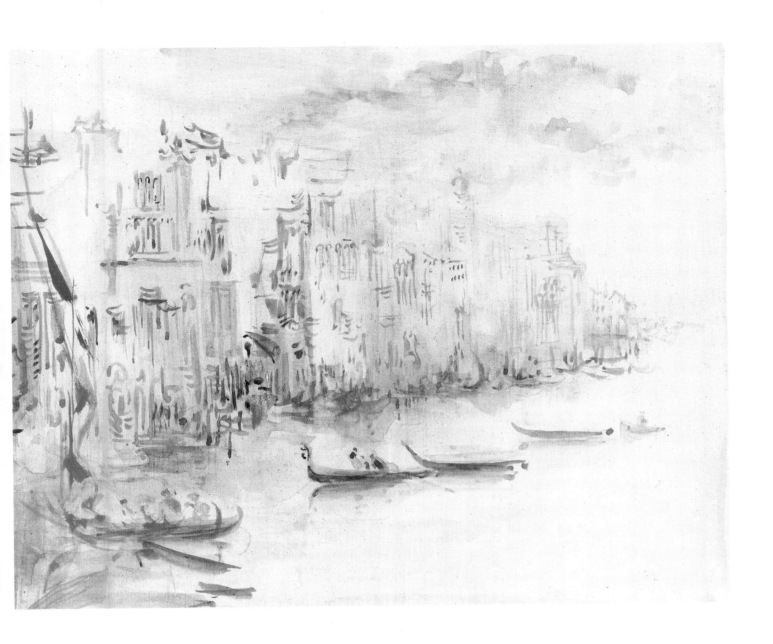

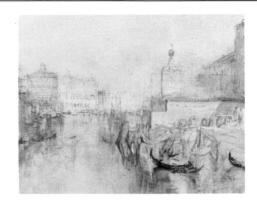

Detail from the original: gondolas

Size: 320 × 265mm (12¾ × 10½ in)
Colours: yellow ochre, lemon yellow, cobalt blue, rose madder

This detail comes from the right-hand side of the original painting and takes as its focus the gondolas lying in the foreground.

In this demonstration you are shown how to interpret the subject-matter more freely.

Stage 1

Once you have completed your basic pencil work, apply a warm tone to the whole drawing. Make sure that you dampen the paper first so that you can apply the ground uniformly, otherwise there is a danger that it will look slightly patchy. Use a warm yellow mixture of yellow ochre and some rose madder, or alternatively, a thinned tone of sepia ink.

If you wish, then you can change the ground colour slightly. For example, a hint of blue can be used to express an evening mood, an effect which will be increased if you apply a yellow light to the windows and to the reflections in the water.

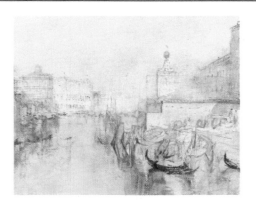

Stage 2

Use a warm mixture of lemon yellow and rose madder to trace in the architectural structures. Load your brush well so that you can work energetically over the surface.

It is a good idea to keep a water-filled brush readily to hand, so that you can quickly thin down areas where the colour is too heavy.

Paint the ground whilst it is wet. Then, use relatively dry strokes to draw in individual forms.

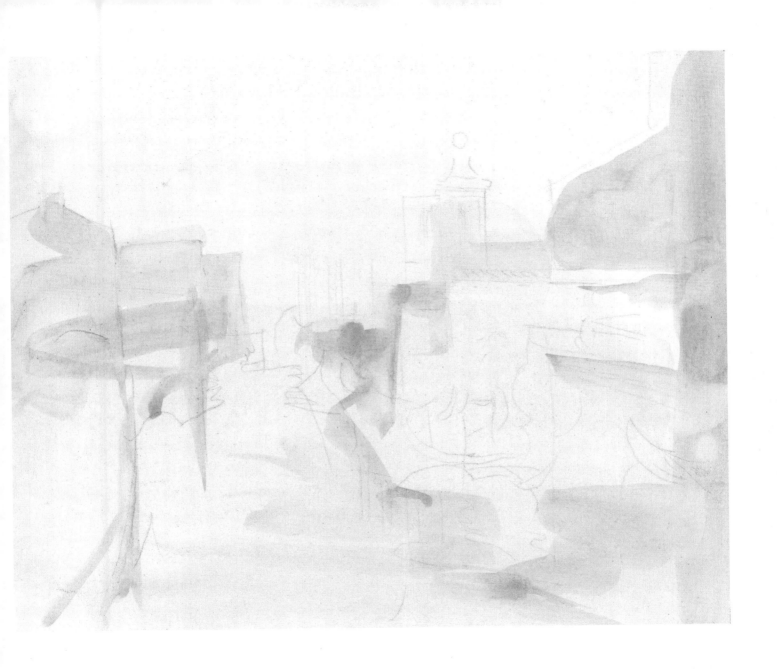

31

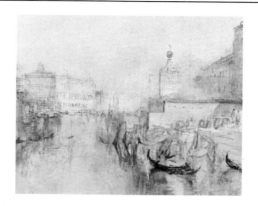

Stage 3

Carefully erase the drawing here and there. Then, moisten the sky and apply a very thinned tone of cobalt blue, using light, irregular strokes to give the impression of delicate clouds.

Proceed in a similar way for the water surfaces. Paint in a smooth zigzag from back to front, applying blue to the boats in the background as well. Use a finer brush to create the shadows in the water.

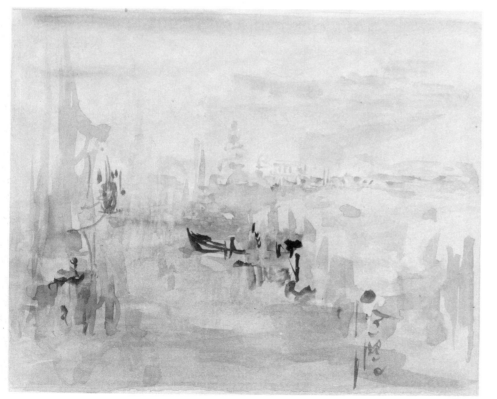

A possible free interpretation of Turner's view.

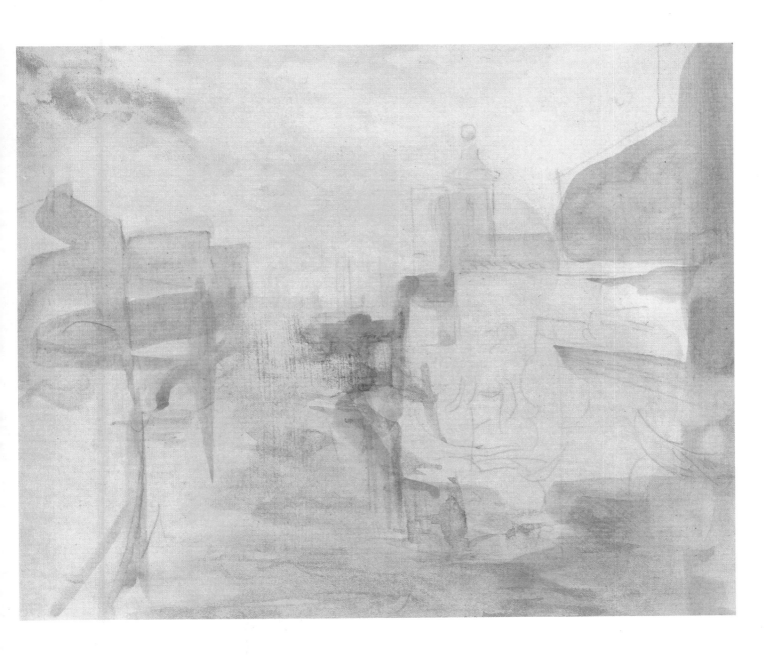

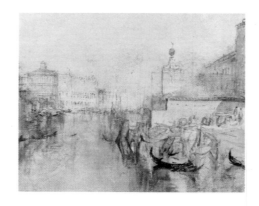

Stage 4 – the finished painting

Emphasize the boats' shadows in the water, using cobalt blue to which a little rose madder has been added. Spread the colour with a wet brush. Use the same colour tone with a thinner brush for the finer shadow effects and for the right-hand building. Apply individual colour emphases with a warm mixture of lemon yellow and rose madder.

Next, paint the boat on the right-hand side with a dark brown tone mixed from rose madder, lemon yellow and cobalt blue. Thin this down for the reflection in the water.

Rose madder, lemon yellow and just a trace of cobalt blue supply the red colour used for the other boats and for their reflections in the water. These reddish colour effects are important aids to the pictorial structure.

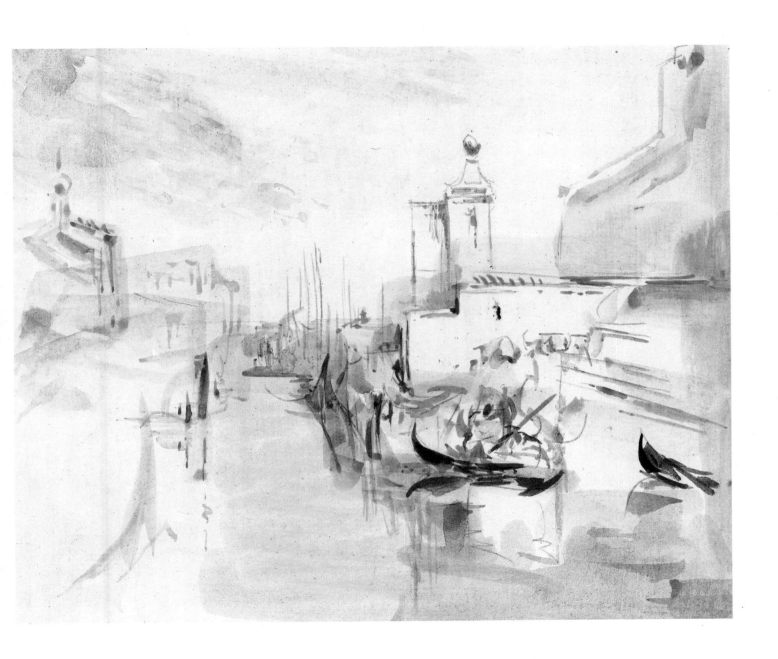

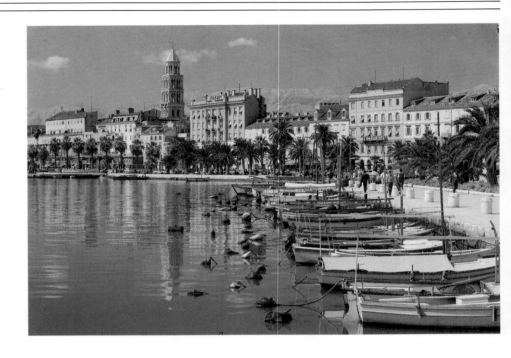

Studies from photographs

Townscape

Size: 320 × 255mm (12¾ × 10¼ in)
Colours: yellow ochre, lemon yellow, cobalt blue, rose madder, burnt umber

This view of the town of Split in Yugoslavia is, in many ways, similar to Turner's watercolour of the Grand Canal. Like his painting, the photograph depicts the facades of houses and boats in the water.

In this demonstration the photograph is interpreted in a similar manner to Turner's original painting, so that a typically Turneresque mood results.

Stage 1

Sketch the subject with a few pencil strokes, lightly erasing any that are inaccurate or too emphatic. The drawing is intended to serve only as a basis, or skeleton, on which to build your brushwork.

Moisten the paper before applying a ground of yellow ochre and some rose madder.

Stage 2

Touch the sky with pure cobalt blue, thinning the colour with differing amounts of water in order to obtain tones of varying strength. It is important always to moisten the ground with water beforehand and then to work fluidly. Repeat the blue tone in the shadows on the water and on the trees.

To obtain Turner's typically effortless effect and his diffuse light, work over the blue areas of the sky and the trees in the background with a wet brush, thus toning down the colour.

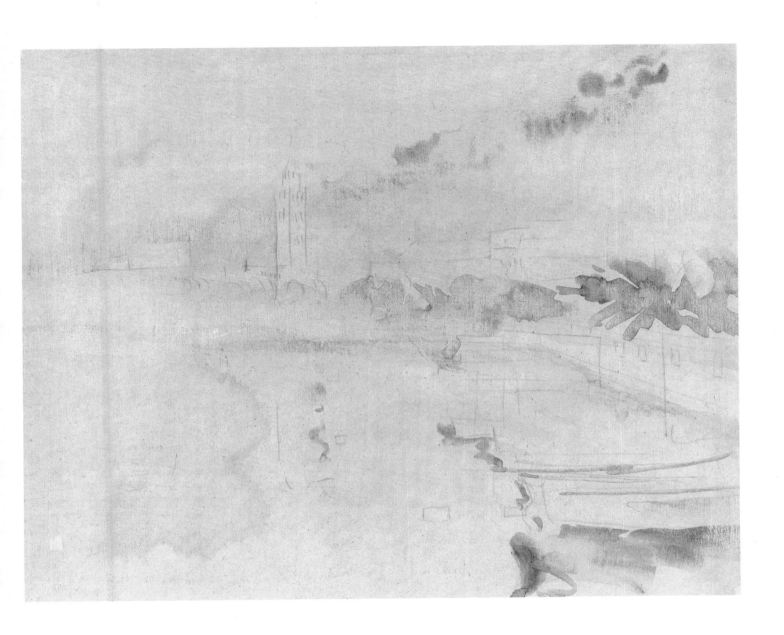

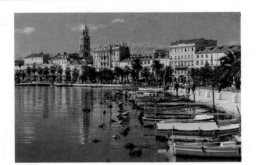

Stage 3

Add further details and subsidiary lines lightly in pencil.

Use a reddish tone, mixed from rose madder and burnt umber, for the water and for the shadows on the roofs and on the boats to the right.

Mix rose madder, yellow ochre and cobalt blue to obtain a darker tone, and use this where necessary to emphasize the window niches, the outlines of the buildings, and the shadows of the trees and the boats. Apply the paint in a careful and detailed way.

Use a mixture of lemon yellow and rose madder to reproduce the light and colour effects on the house facades, the surface of the water and the boats to the right.

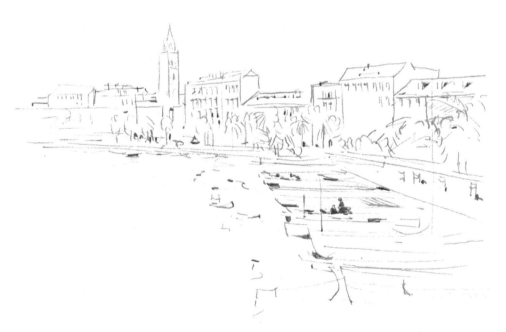

A separate sketch will serve as a useful guide when adding the details to your composition.

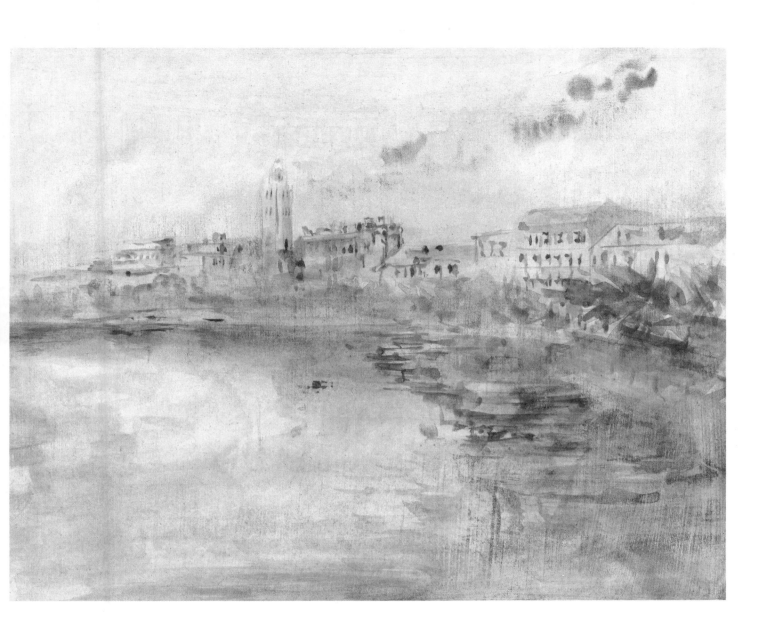

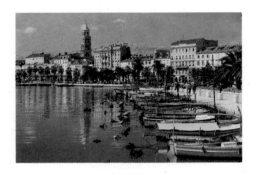

Stage 4 – the finished painting

Once the washes are dry, the true effect of the colours will become apparent. Moisten the areas which seem too dark and remove some of the colour with a stippling brush.

Next, apply a mixture of cobalt blue, lemon yellow and a touch of rose madder to the surface of the water in the foreground and to the right. Paint the trees and the details of the buildings in the same greenish tone.

Emphasize the boats in the foreground and the buoys with a strong tone of rose madder, yellow ochre and cobalt blue. Then, partly wash over the outlines which still seem quite strongly delineated.

Use pure lemon yellow to illuminate the edge of the quay and the boats. The shadows here can be heightened with yellow and a generous application of rose madder.

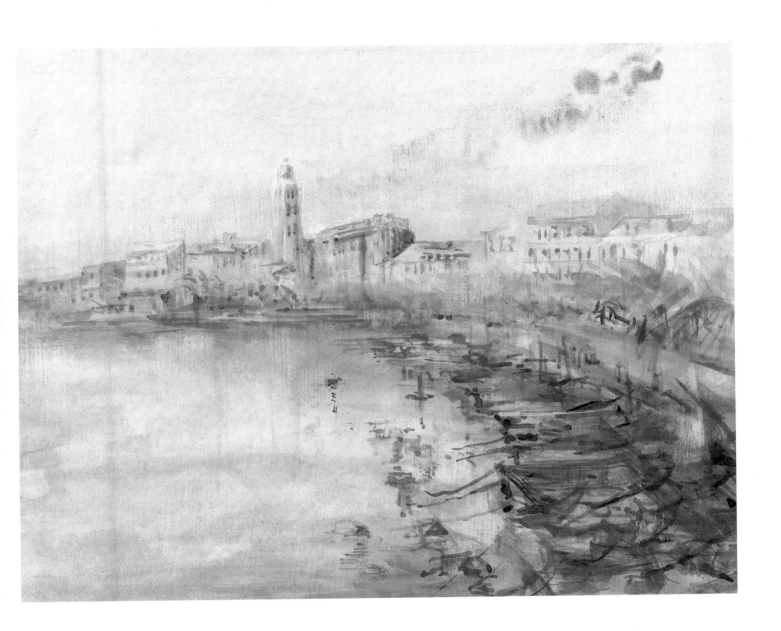

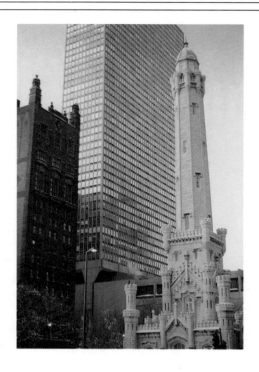

Skyscraper

Size: 255 × 320mm (10¼ × 12¾ in)
Colours: yellow ochre, lemon yellow, cobalt blue, rose madder

Chicago's world of skyscrapers is a subject which, in spite of its modernity, lends itself to adaptation along the lines of Turner's watercolour of the Grand Canal. In this photograph, in place of the old Venetian houses which dominated the left–hand side of Turner's original painting, there is the architecture of the present day.

Once again, sketch the overall composition freely. The effect of the picture should come from the tension between the large, undetailed surfaces and the smaller, detailed areas. The colours are not reproduced naturalistically but are used to express mood and atmosphere.

Stage 1

Establish the composition with a few pencil lines, taking care not to make the basic drawing too detailed. If necessary, then you can always add some pencil work at a later stage, provided that you only do so when the paper is dry.

In order to create a more balanced picture, the large skyscraper in the middle has been shortened a little at the top.

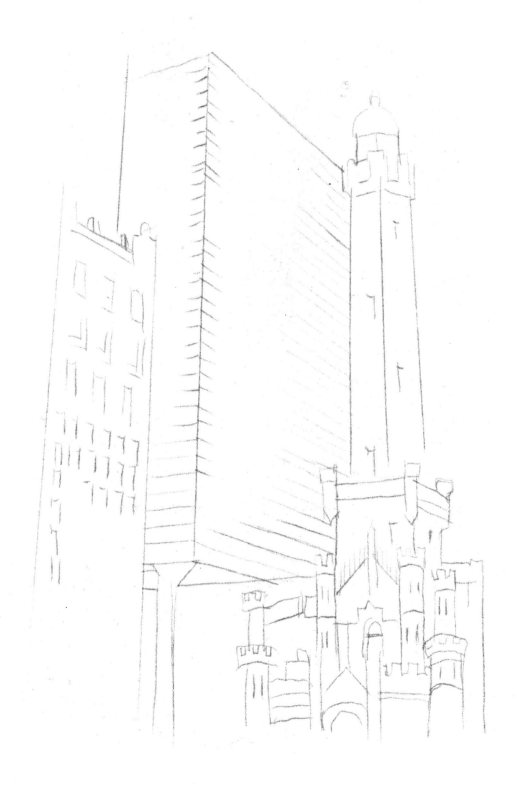

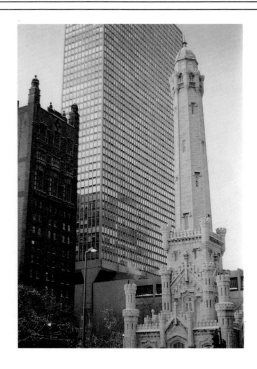

Stage 2

Moisten the paper first, and then apply a very soft ground of yellow ochre and lemon yellow.

Moisten the sky in the upper section of the picture with water, and then allow a heavily thinned tone of cobalt blue to flow into it. The sky should not have a monotone effect, and small areas here and there should be left free of colour. This is very important if you are trying to achieve a rather diffuse overall effect.

Without any preliminary moistening, also apply soft cobalt blue to the shadowy areas of the architecture. Paint freely along the structural lines, using a broader stroke and thinner colour for the house surfaces.

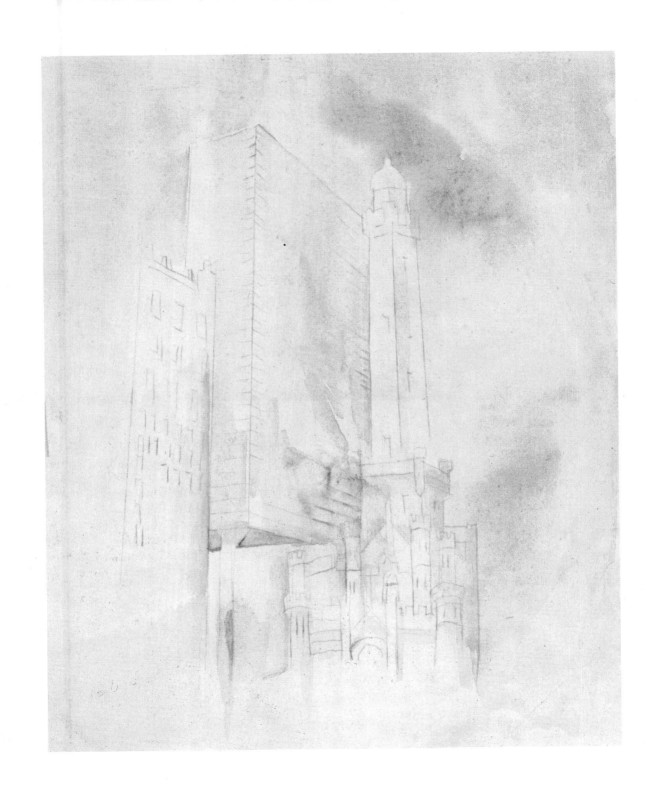

47

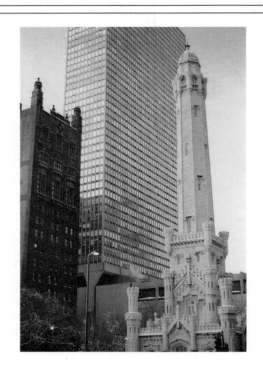

Stage 3 – the finished painting

Use a bright mixture of lemon yellow and rose madder to emphasize the part of the architecture in the light. Apply the brush to the edges of the building and draw it vertically downwards. Directly below this, use a water brush to spread the colour over the houses. If you intensify the washes here and there with the same tone, then you will soon obtain an effect of depth. Now use a flat brush to extend the colour downwards into the foreground of the picture.

Use a slightly reddish tone of lemon yellow and rose madder for colour emphases on those parts of the buildings which are in half-shadow.

To deepen some of the shadow areas, mix cobalt blue with a little rose madder. Moisten the lower part of the picture in advance, so that the colour runs. In other areas, apply sharply-defined dark edges.

Once these washes are dry, you can add the details to the composition. Using a fine brush, apply a reddish mixture of rose madder, cobalt blue and lemon yellow to the windows, turrets, niches and other outlines. Use a full brush to obtain the colour nuances which result from the varying intensities of light. This gives the picture an almost three-dimensional effect.

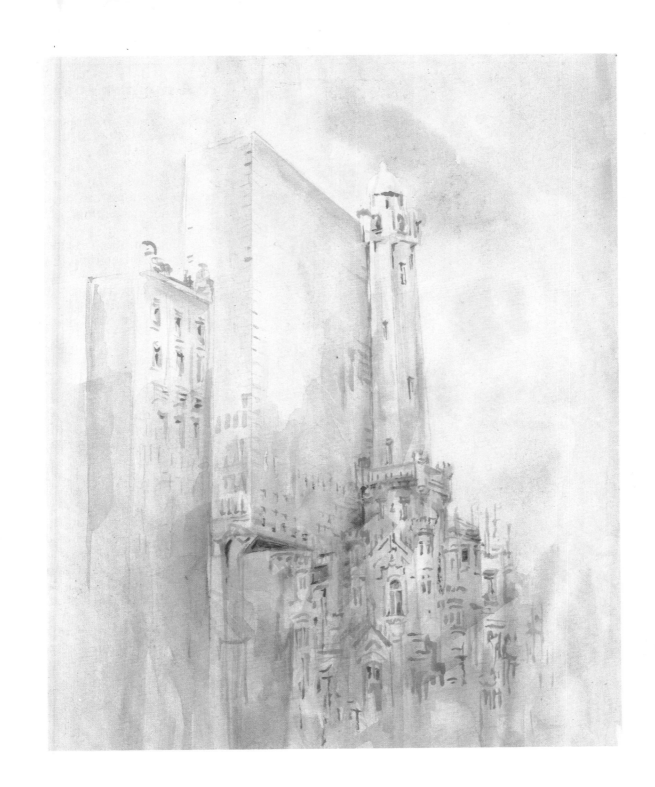

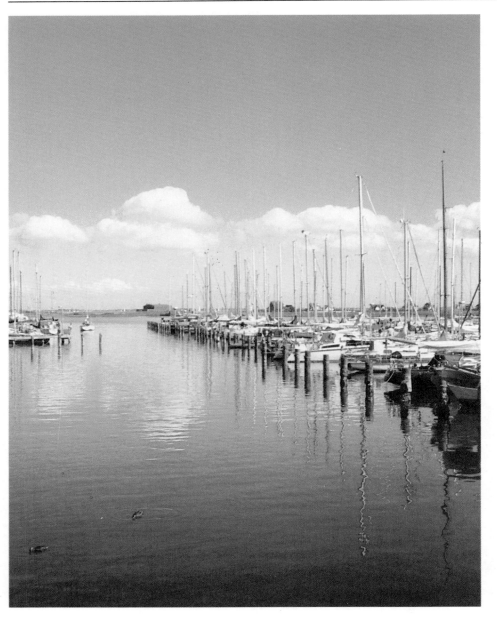

A summer's day

Size: 320 × 265mm (12¾ × 10½ in)
Colours: yellow ochre, lemon yellow, cobalt blue, rose madder

This photograph returns to the subject of boats, as depicted also in Turner's painting of the Grand Canal.

The common theme bridges the two periods in time, and the following translation of the photograph into watercolour shows that Turner's methods are also effective in today's technological world.

Stage 1

Sketch the subject with a few strokes of the pencil. Screw up your eyes a little until you can distinguish only the large areas of light and dark; this will help you to reduce the composition to a minimum.

Moisten your paper first, and then apply a ground in two different tones: a heavily thinned cobalt blue and a warm yellow mixed from yellow ochre and rose madder.

If you prefer to paint 'from nature' rather than from a photograph, then do not worry about the constantly changing light. Simply continue with the picture as you originally envisaged it.

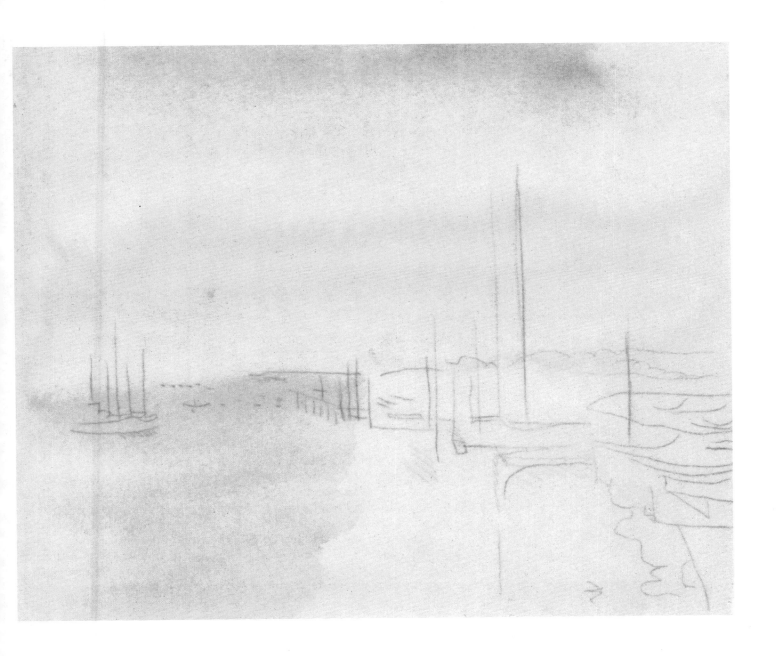

51

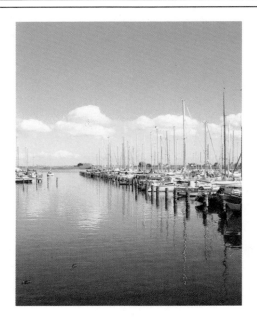

Stage 2

Use a mixture of cobalt blue and a little yellow ochre to indicate the horizon, and use it also for the shadows on the water and on the boats.

Apply a soft red tone, made from lemon yellow and rose madder, to the greenish washes in the background on the right of the picture. Repeat the same tone for the lighter areas of the boats.

Mix rose madder, yellow ochre and cobalt blue for the very dark shadows. It is a good idea to alternate between very fine and more powerful brush strokes, and between a quite thin and a more generous application of colour. Where the colours are repeated as reflections, use a water brush to obtain an especially soft effect.

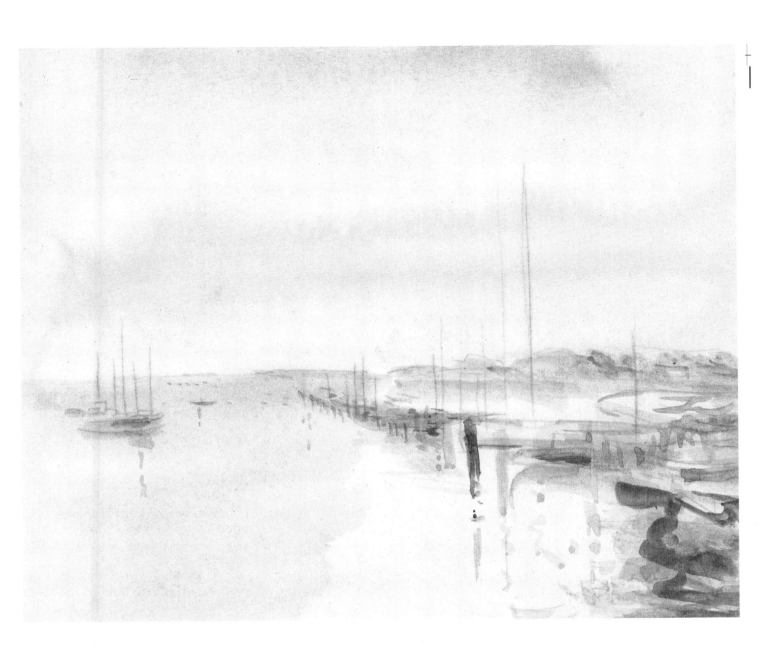

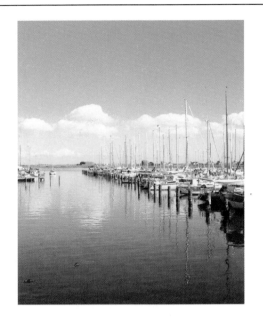

Stage 3 – the finished painting

Carefully erase the preliminary drawing. Then, using a mixture of rose madder, cobalt blue and a trace of lemon yellow, apply additional colour accents to the boats and the piles on the right-hand edge of the picture. This scarcely-thinned, strong tone heightens certain points and contributes to the structure of the composition by emphasizing the effect of space. If you wish, then you can use sepia ink instead of this mixture.

Add the final details of the boats with a soft orange tone mixed from lemon yellow and rose madder.

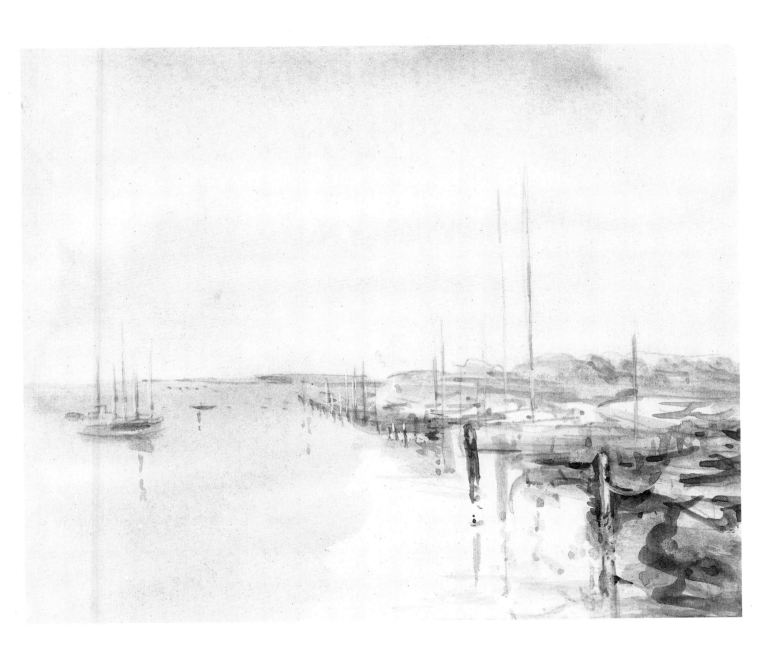

Venice from Fusina

Original watercolour by Turner

Size: 302 × 224mm (12 × 9in)

Analysis of a painting and its reconstruction are of great value in acquiring a more detailed knowledge of a painter's methods. Confidence and inspiration are often the results.

The pictorial structure of Turner's watercolour *Venice from Fusina* (*c.*1840) is analysed here. If you wish, then you can reconstruct this painting using the colours indicated.

The paper has a warm yellow ground. Considerably thinned violet clouds (cobalt blue and rose madder) are applied to the moist ground, whilst the clouds in the left-hand part of the picture are painted with a horizontal stroke on dry paper. The horizon appears as a line in the same violet tone.

The yellow cloud area and the vermilion passages (rose madder and lemon yellow) are applied directly above the water.

The water area is painted with a soft tone of cobalt blue, and a greenish wash (cobalt blue, lemon yellow and a little rose madder) is then applied on top. A stronger application of the same tone is used to indicate the shadows on the water and the small waves. The latter are sketched on the dry paper. The blue wash still shows in the foreground so that the water appears bright in this area.

The boat and the piles are painted on a dry ground with sepia (cobalt blue, rose madder and lemon yellow) or with a sepia wash. Vermilion (rose madder and lemon yellow) is applied to the piles at the front; a stronger red (rose madder) is used on those in the background.

The deepest tones (sepia and cobalt blue) are applied to the reflections in the water.

The composition, the warm blurred colours, and the shimmer which seems to cover the whole design, radiate peace and harmony. This picture is an example of the impressionism which Turner brought to a fine art, and which placed him very much in advance of his own times.

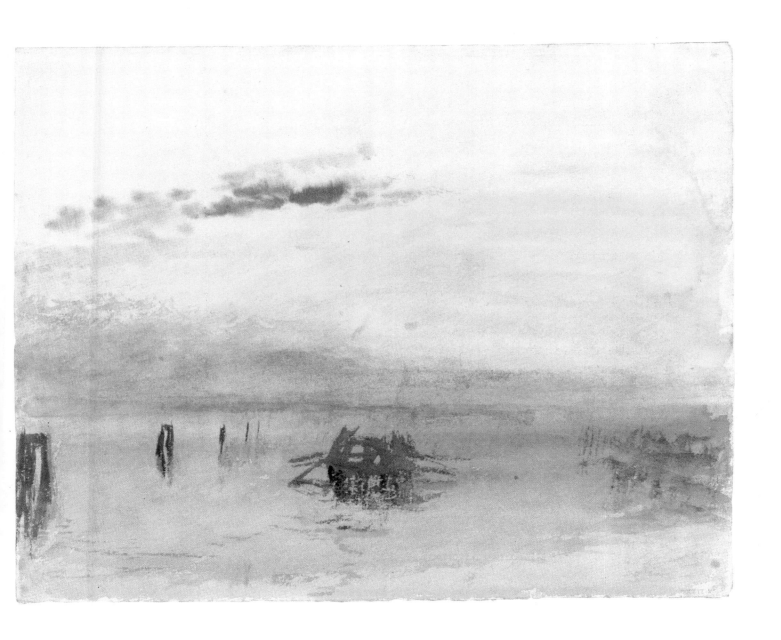

Studies from photographs

Boats in a thunderstorm

Size: 320 × 250mm (12¾ × 10in)
Colours: yellow ochre, lemon yellow, cobalt blue, rose madder, Chinese white

When painting landscapes it is especially important to adhere to the Golden Section. This means that the composition is designed in a ratio of 1:2, that is, one part of land or water to two parts of sky, or vice versa.

If there is a horizon right across the picture, then a diagonal will greatly

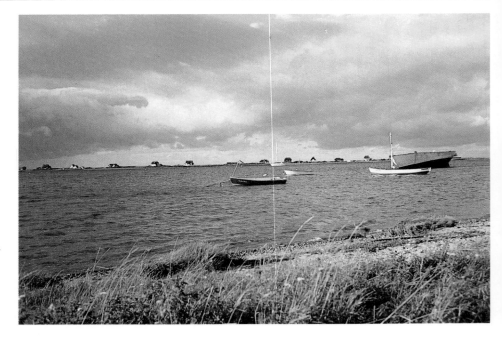

enliven it. In the photograph, for instance, this is provided by the grass on the bank in the foreground. The following pages show how to translate this photograph into a painting in the style of Turner's watercolour *Venice from Fusina*.

Stage 1

Turner often painted on a dark coloured paper. For example, at Petworth, in 1833, he produced a series of watercolours on buff-coloured paper. To some extent, he also created his own ground of darker tones.

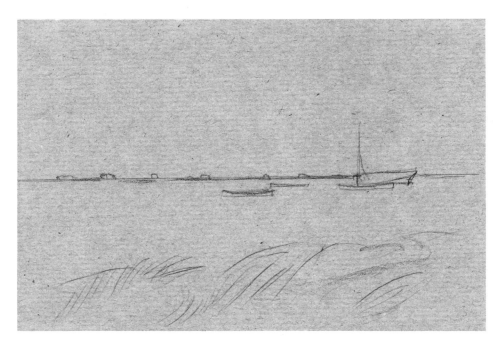

The demonstration paintings on the following pages have been worked on a dark paper. If you wish to paint on a white or a light-coloured paper, then you can use the kind of multi-coloured ground shown here. Once again, apply the colours to a moistened ground.

Sketch the boats, houses and islands with a few pencil strokes. The result will be an interesting picture in itself, which recalls Turner's painting *Venice from Fusina*. For a further comparison, see Turner's late watercolour *Lakeside Castle* (1820–30).

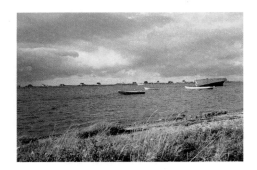

Stage 2

The colour samples shown below have been applied to white paper. If you are working on a coloured paper, then use a piece of this for your colour tests. Wait until the colours are dry before checking them, as the result on a dark ground will be different from that obtained on a light ground.

Vigorous brushwork indicates the threatening atmosphere before the storm.

With a mixture of cobalt blue, yellow ochre and rose madder, apply a wash to the sea and the sky using generous brush strokes. Use a reasonable amount of water to produce a soft colour transition in the sky. Paint the sea generously with a long flat brush filled with colour. Reproduce the vegetation in the foreground rhythmically and vigorously, and use the same tone to indicate the houses on the horizon and the boats. Then, apply a yellow ochre wash to some areas.

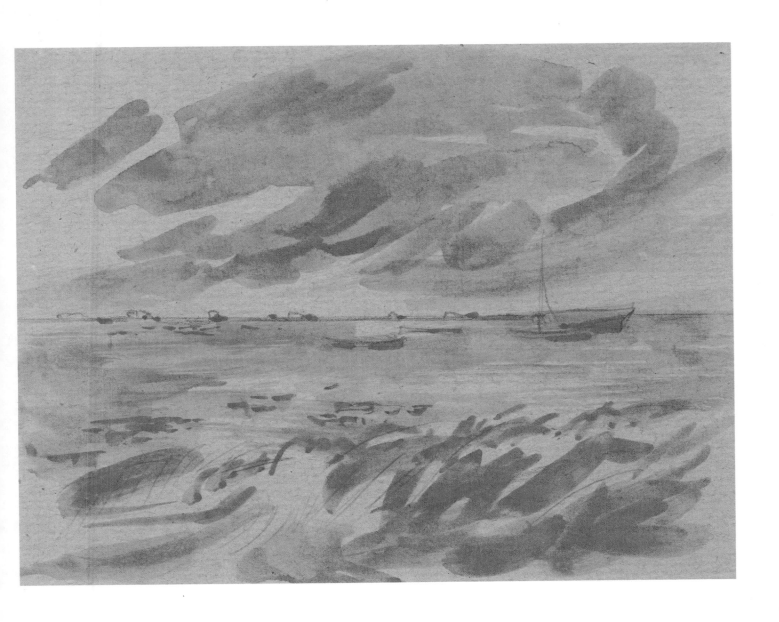

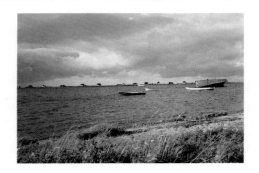

Stage 3

Apply soft tonal washes of yellow ochre, heightened with a little lemon yellow, to the sky and to the surface of the water.

The light effects are obtained using Chinese white on the buff ground of the paper. Apply this to the sky, to the grassy area in the foreground, to the light details of the boats, and to the little houses on the horizon. The white gives a transparent effect and helps to structure the picture.

Enliven the sky with vigorous cobalt blue strokes, and use these also on the water and the vegetation.

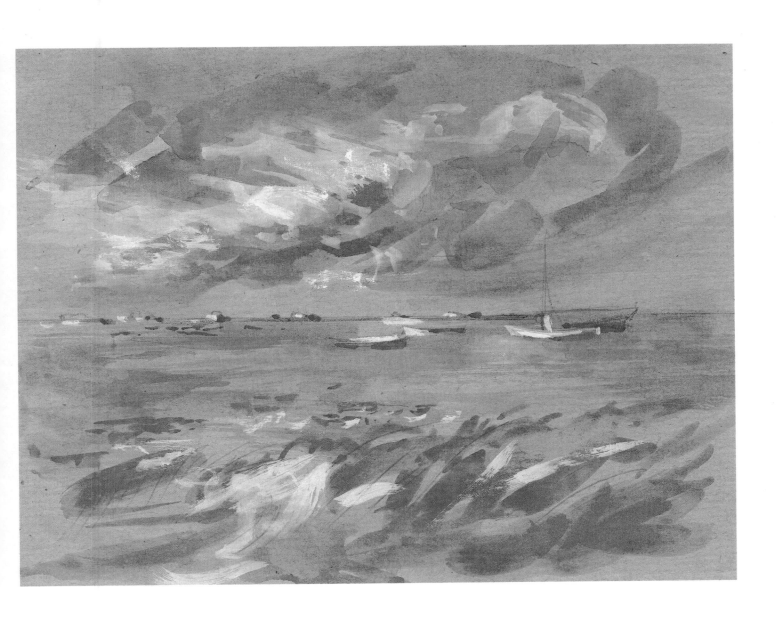

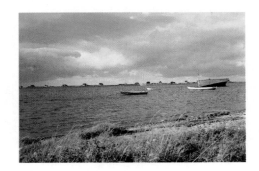

Stage 4 – the finished painting

Use fine flourishes of a red tone, made from rose madder and lemon yellow, to accentuate the vegetation in the foreground. If the red tones are too strong, then reduce the effect with water. A pale wash will join the brush strokes at certain points.

Use the same tone to paint isolated reflections on the water. The colour brings out the stormy atmosphere.

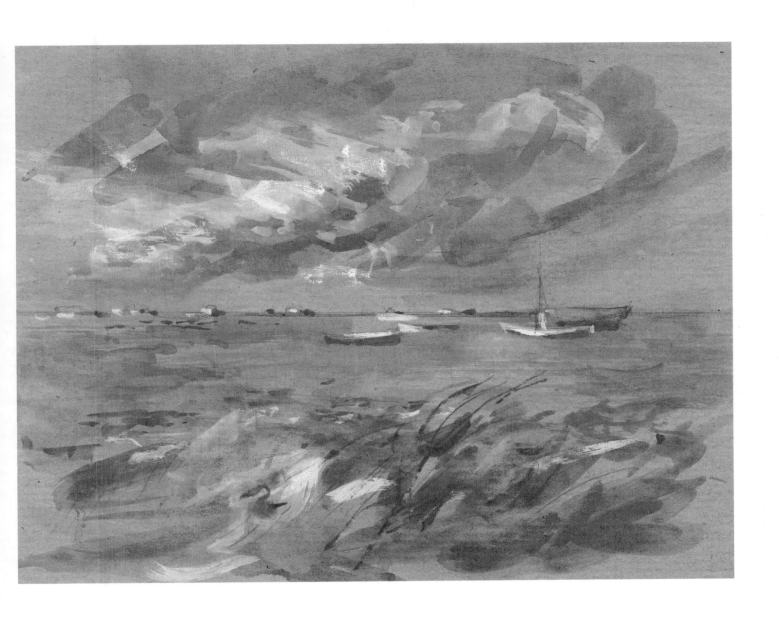

Sailing boats in a harbour

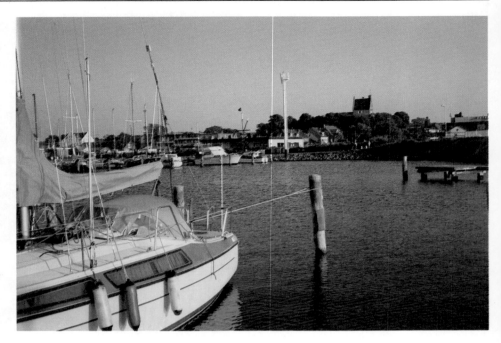

Size: 320 × 270mm (12¾ × 10¾ in)
Colours: yellow ochre, lemon yellow, cobalt blue, rose madder

Turner seldom allowed himself to be seen at work. Those privileged to see him paint reported the speed with which he assembled the individual areas of the picture into a whole. The success of his fluid approach in summarizing boats, water and houses without neglecting detail testifies to his genius.

The subject of sailing boats in front of a landscape is another possible parallel to Turner's watercolour *Venice from Fusina.*

The mood is expressed by the colours used; reddish tones denote a morning atmosphere, and bluish tones an evening mood. Diffuse colours indicate haze or mist.

Stage 1

Summarize the subject with a few generous pencil strokes, and then apply a very soft, vertically-directed wash to the drawing, using cobalt blue and a little yellow ochre.

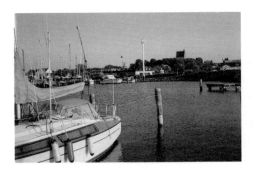

Stage 2

Moisten the ground before painting the silhouettes of the buildings in the background, using a mixture of rose madder, lemon yellow and cobalt blue. Use the same tone for the outlines of the boat in the foreground. Draw a water brush over adjacent areas to achieve smooth colour transitions. Paint lines and shadow areas on the still moist washes. The picture already has a clear structure.

When building up the drawing, remember that certain major elements of the composition – verticals and horizontals, diagonals and curves – decide the tension and harmony of a picture.

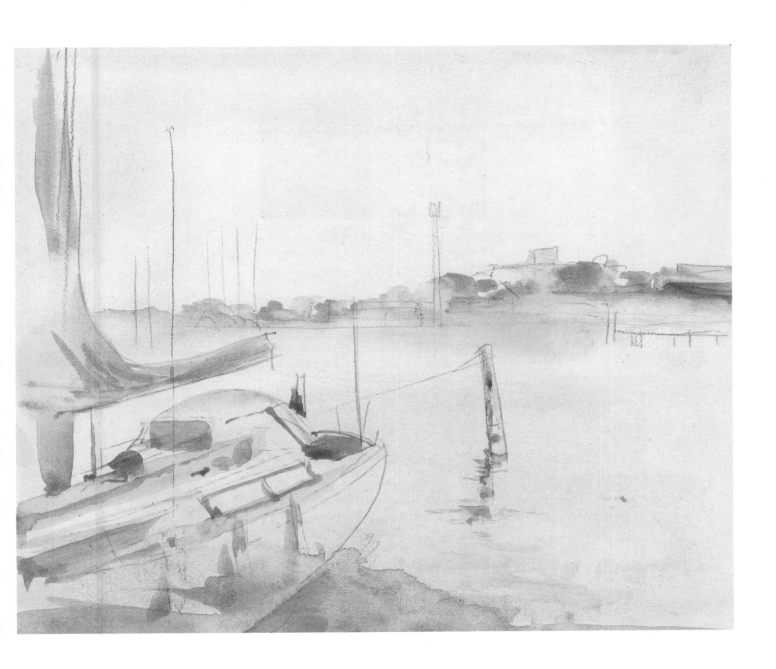

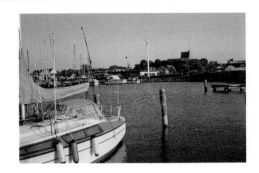

Stage 3 – the finished painting

Carefully erase large areas of the preliminary pencil sketch.

Next, apply a wash to the boat, the piles in the foreground, and the coastal landscape, using a warm yellow tone mixed from lemon yellow, rose madder and a trace of cobalt blue.

Increase the amount of rose madder and apply individual traces of colour to the landscape and to the boat.

Finally, delineate the boat further with a darker mixture of cobalt blue, lemon yellow and a little rose madder. These unthinned strokes make a major contribution to the painting's almost three-dimensional effect.

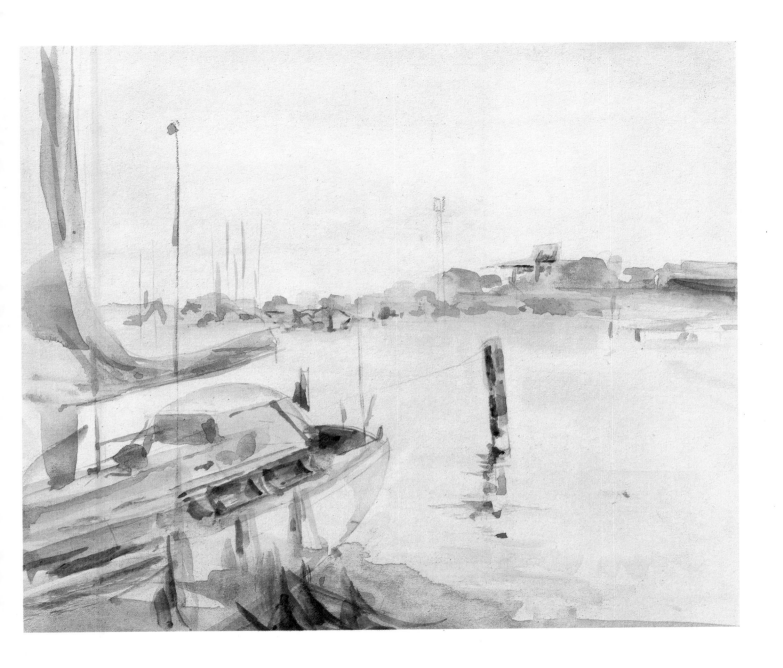

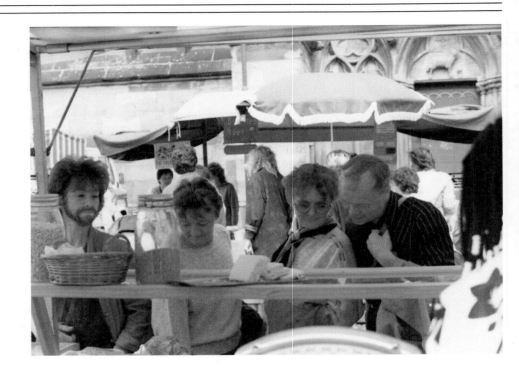

Market scene

Size: 320 × 220mm (12¾ × 8¾ in)
Colours: yellow ochre, lemon yellow, cobalt blue, rose madder, Chinese white

Turner often spent time at Petworth with his friend Lord Egremont. As he walked in the neighbourhood and in the old lanes of the town he found material for his sketches everywhere. He produced a number of watercolours on these occasions, including *In Petworth*, a market scene which he painted in 1830. This photograph, which is freely translated into watercolour on the following pages, is related to the painting *In Petworth*.

Stage 1

An Ingres paper with a blue-grey tone has been used for this watercolour. This highly effective paper is obtainable in a number of different shades.

At the preliminary drawing stage, use as few strokes as possible for the basic composition. Keep only the most important elements, which are typical of a market scene. You can add individual details at any time when applying your colour.

Stage 2

If you use toned Ingres paper, then make colour tests on a piece of this paper and prepare a preliminary colour sketch as well.

Lightly erase pencil lines which seem too harsh, and then use rose madder mixed with a little lemon yellow for the figures and other important compositional elements.

Finally, use thinned rose madder to add nuances to some areas of this first wash.

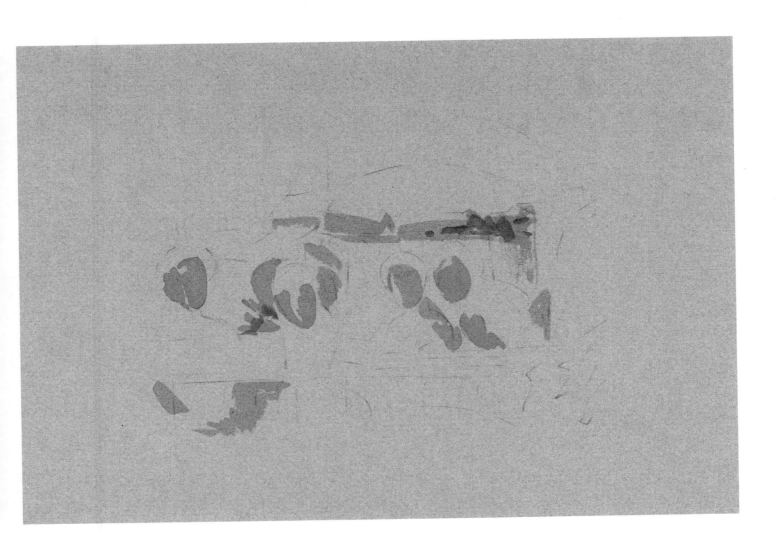

Stage 3

Emphasize the figures further and indicate details of the market scene with a mixture of rose madder, yellow ochre and cobalt blue. You can obtain various shades by lightening the colour with water or by increasing the amount of rose madder. Accentuate some of the already washed areas by laying a violet tone, made from cobalt blue and rose madder, over them. Using the same tone, pick out the umbrellas of the market stands in the background.

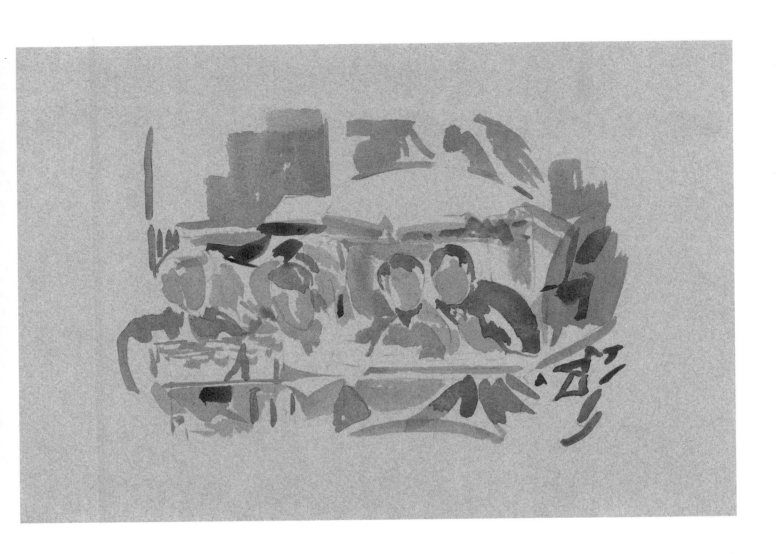

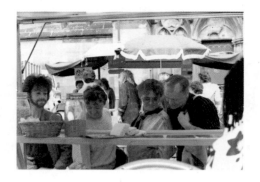

Stage 4 – the finished painting

Now apply the colour accents. Use rose madder mixed with lemon yellow for the head of the left-hand figure and here and there on the market stall. Emphasize the diagonals in the same tone.

For the light areas of the composition, use white broken with rose madder and cobalt blue. This provides the colour contrasts on toned paper which are essential to any watercolour.

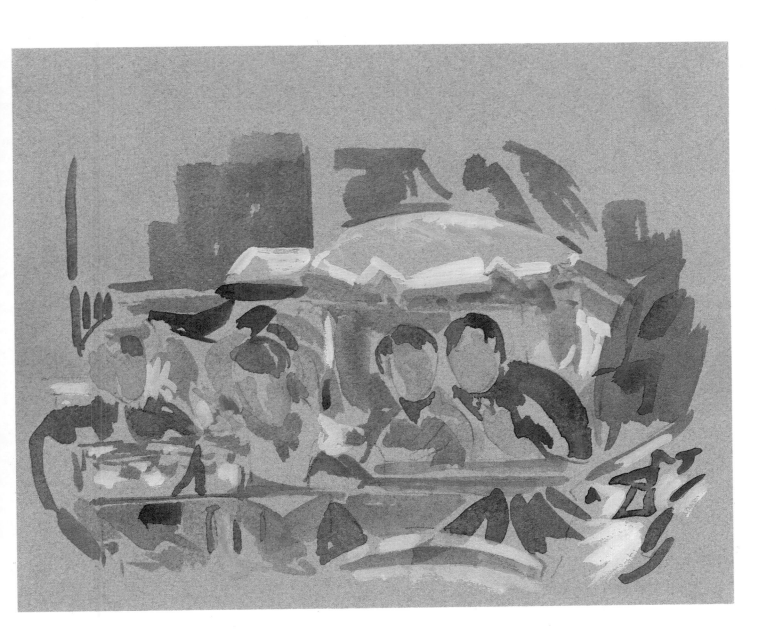

First published in Great Britain 1992
Search Press Ltd.,
Wellwood, North Farm Road,
Tunbridge Wells, Kent TN2 3DR

Originally published in Germany, under the title *Malen wie die Meister/Aquarellmalerei im Stil von William Turner*, by Christophorus-Verlag GmbH, Freiburg im Breisgau

Translated by John Griffiths

This edition distributed to the trade in the United States of America by Arthur Schwartz & Co, 234 Meads Mountain Road, Woodstock, New York 12498

ILLUSTRATIONS: page 7, *Venice: the Grand Canal, looking towards the Dogana* (1840) by J.M.W. Turner, watercolour and gouache with pen and red ink, 320 × 221mm (12¾ × 8¾ in), copyright © British Museum, London; page 57, *Venice from Fusina* (c.1840) by J.M.W. Turner, watercolour, 302 × 224mm (12 × 9in), copyright © British Museum, London.
PHOTOGRAPHS: page 36, Toni Schneiders; page 44, Georg Peez; pages 50, 58 and 66, Rosemarie Heuer; page 72, Archiv HSL.

If this book is used for teaching purposes, then please acknowledge the series *Learn from the Masters*.

Publishers' note
There are references to animal hair brushes in this book. It is the Publishers' custom to recommend synthetic materials as substitutes for animal products wherever possible. There are now a large number of brushes available made of artificial fibres and they are just as satisfactory as those made of natural fibres.

ISBN 0 85532 734 0 (Pb)
ISBN 0 85532 722 7 (Hb)

Composition by Genesis Typesetting, Rochester, Kent
Printed in Germany

Other books published by Search Press

LEARN FROM THE MASTERS
Other titles in this series include:
Volume 2 Cézanne;
Volume 3 Van Gogh;
Volume 4 Gauguin.

Using a simple, easy to understand approach, each volume reconstructs a popular watercolour painting and shows how, using these techniques, you can produce your own contemporary painting in the style of one of these Great Masters.

LEISURE ARTS
There are over 30 titles in this popular, widely acclaimed series of oil, watercolour, pastel, gouache and acrylic teach-yourself painting books. All the secrets of successful painting are clearly explained by well-known artists, together with step-by-step full colour demonstrations.

UNDERSTAND HOW TO DRAW
This series of 'how-to-draw' books is written and illustrated with sketches and drawings by professional artists to encourage the beginner to develop his or her drawing skills. Many different techniques and methods are explained, and a broad selection of subjects is covered, such as trees, flowers and plants, buildings, landscapes and animals.

KEY TO ART
These beautifully illustrated, pocket guide books are for art lovers and art students alike. There are six titles in the series, covering Renaissance art, romantic and impressionist art, Gothic art, modern art and baroque art. Each title provides a comprehensive background and brief history of the subject, and all are illustrated with a wealth of photographs of selected masterpieces to highlight important points.

There are many other painting, drawing and calligraphy titles published by Search Press. If you would like to receive a free copy of our colour catalogue and information about how to order, write to Dept B, Search Press Ltd., Wellwood, North Farm Road, Tunbridge Wells, Kent TN2 3DR, England. Telephone 0892 510850.